The 'Zen' in Zentangle®

The word Zen means meditative state. It describes the creative energy that an artist experiences when the work or design creation is allowed to flow naturally from your consciousness without being forced.

Art created in this manner touches the viewer in a profound way that is difficult to describe in words because the emotion of the artist - whether it is love, devotion, pain, loss, gratitude or joy - passes into the work and radiates outward.

The process of Zentangle® helps anyone get in touch with life. It opens your awareness to new ideas, helps you solve problems, calms the soul, and fosters your creative spirit.

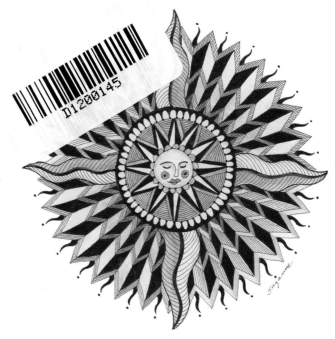

History of Zentangle

Zentangle® was created by Maria Thomas and Rick Roberts. As Maria drew background patterns on a manuscript, she felt an amazing sense of well being, complete focus, and the timelessness that people usually associate with a meditative state. She described this sensation to Rick and together they created a simple system which would allow others to enjoy drawing tangles and experience a similar feeling.

*"Zentangle", the red square, and "Anything is possible, one stroke at a time" are registered trademarks of Zentangle, Inc. Zentangle's teaching method is patent pending and is used by permission. You'll find wonderful resources, a list of Certified Zentangle Teachers (CZTs), workshops, a fabulous gallery of inspiring projects, supplies, kits, and tiles at **zentangle.com**.*

The Zen in Mandalas...

Sacred Circles

Infinite, with no beginning and no end, the circle has a long history as a sacred symbol. It is the shape our ancestors saw when they looked at the sun and moon; it is the shape we see when we view our planet from space. It is the shape of raindrops and puddles, fruits and berries. Even our eyes, the windows of the soul, are circles.

Possessing balance and symmetry, circles represent the calm surrounding a point of creation.

Center of Life

Beginnings are delicate. They contain potential energy, hope, endless possibilities and expectation. Beginnings can be explosive, as in the birth of a star or a baby, or they can be as gentle as the opening of a seed pod.

As the sun is the source of energy and center of our universe, the center of the mandala is the starting point for its creation. Your thoughts at the moment your pen touches paper turn potential into reality.

Expanding Life

The universe is infinite and ever expanding. Mandalas express this idea with spirals. Like circles, a spiral is never ending. Instead of tracing over itself, it continually reaches into new territory, exploring and growing.

Symmetry

Symmetry is a corresponding arrangement of parts on each side. Nature abounds with symmetry. Night complements day... there are both storms and calm, clear skies and clouds. The earth rests all winter in preparation for the growth of spring.

Human emotions are also symmetric. Love counters hate, joy opposes sadness. Greeks defined beauty by the degree of symmetry. In their view, symmetry equated with perfection.

Balance

Everywhere in nature, there is balance. No element is more important than the others. All work in harmony. Health and happiness abound when balance is present. The sage fills his time with both rest and activity and appreciates the value of both.

As in nature, mandalas include both flexible curves and rigid squares.

Relaxation

Stress enters our lives when we become overwhelmed, and forget what is most important, and go through the day reacting to events. Practicing Zentangle allows your mind to slow down. Worries retreat into the background. Your muscles begin to soften, flowing with the ink of the pen as you fill spaces with tangles.

Meditative

The repetitive nature of each tangle frees your mind from the pressure to make decisions, to take control, and to judge outcomes. The calm that proceeds from quieting the mind opens to a heightened sense of awareness. Insights come to the fore, changing your attitude and your behavior.

Practicing Zentangle encourages a meditative state that provides a space to examine your thoughts, evaluate your pursuits, and create dreams that nourish your soul.

Focus

Focus determines reality. From ancient times to modern day, philosophers have come to the same conclusion: "As you think, so shall you be." The Zentangle process allows you to shut out distractions.

Learn to pick up your pen and think only of the motion you are making. When you draw 'a mistake', don't worry. As in life, there is no eraser. Incorporate the 'mistake' into the drawing and use this opportunity to create a new tangle.

Enlightenment and discovery begin when you focus your mind and get acquainted with the spirit within.

"Highly productive people have a great sense of balance and harmony in their lives. They are thoroughly familiar with pacing and knowing when to retreat and clear their heads of immediate concerns." Dr. Wayne Dyer

"Anything is possible, one stroke at a time."™
Rick & Maria of Zentangle

Mandala – PentTangle

by Margaret Bremner, ©2010

Size: 11" round

Add joy to your mandala with color.

Margaret used *Sakura* Micron 01 color pens to draw this design and the tangles. She added an acrylic paint wash for pale background colors and added darker colors with colored pencils.

Photo credit: Grant Kernan, AKPhotos

"Every now and then, go away. Have a little relaxation, for when you come back to your work, your judgment will be surer... from a distance, more of the work can be taken in at a glance and any lack of harmony or proportion is more readily seen."
Leonardo da Vinci

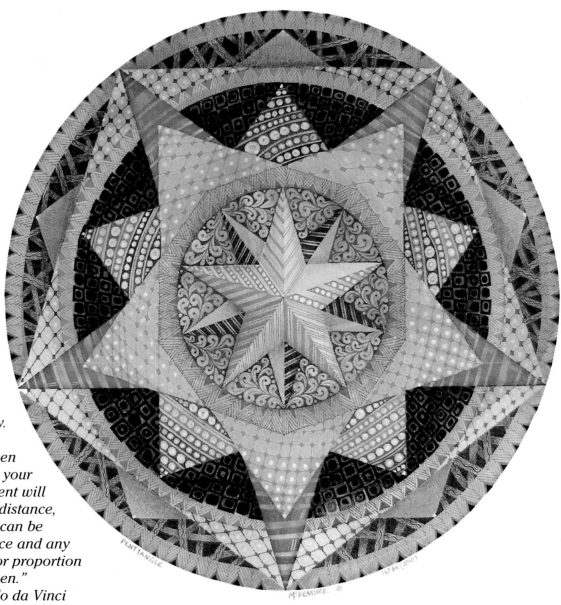

Making a Mandala

Getting Started...

a pencil

a black permanent marker
Micron 01 Pigma pigment ink pen
by *Sakura* is suggested

a compass or
circles template

smooth art paper
a $3^1/_2$" x $3^1/_2$" tile is suggested

Draw a $3^1/_4$" diameter circle
on your tile

Simplicity

In a culture where 'more is better', many people are discovering that the opposite is true. People all over the world are attempting to simplify their lives and reduce waste by using only what they need.

Zentangle is a perfect exercise in simplicity. Using only a Micron pen and a piece of paper, you can turn an afternoon into a beautiful meditative experience in the form of a mandala that is filled with personal meaning.

Method 1
Traditional Zentangle® in a Circle

What You'll Need

We recommend the basics... a pencil, a *Sakura* 01 Micron pen, smooth paper such as a Zentangle tile, smooth hp watercolor paper or cardstock.

You may also want to use a compass for drawing the circle.

Tip: If you don't have a compass, simply trace around a cup, jar lid, or small plate if you prefer. The advantage of using a compass is that it makes a small hole in the very center of your circle, making the center easy to find.

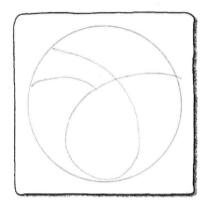

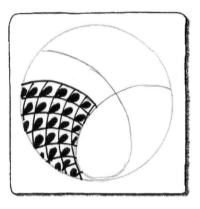

1. Frame
Use a pencil and a compass or round shape to draw a Circle.

Circle of Life
Infinite, with no beginning and no end, the circle has a long history as a symbol of balance and symmetry.

2. String
Use a pencil to draw more circles. Draw lines that create sections.

Path of Life
Dividing our life into sections of love, happiness, work, play... when joined together and filled with tangles these create balance.

3. Tangles
Fill a section with a tangle. Fill additional sections with tangles.

Events
Throughout our life, events fill and color our world. Filling each section with tangles helps recall the events in your life.

Each tangle is a unique artistic design and there are hundreds of variations. Start with basic patterns, then create your own.

With Zentangle, no eraser is needed. Just as in life, we cannot erase events and mistakes. Instead, we must build upon them and make improvements from any event. Life is a building process. All events and experiences are incorporated into our learning process and into our life patterns.

Seedlings

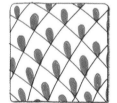

1. Draw a grid of lines.
2. Draw a droplet shape at each intersection of the grid.
3. Color the shape with black.

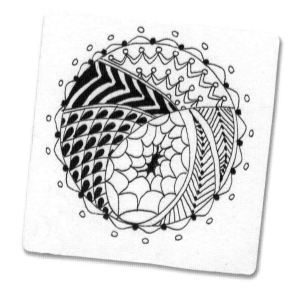

The Path to Inner Peace
Creating a mandala provides an opportunity to retreat from the daily bustle, offering a serene refuge from stress.

Swag

1. Draw small circles in a repeat pattern of lines and rows. 2. Draw swag shapes between the circles with two lines. 3. Color the swags with black.

Neckties

1. Draw a pair of lines. Fill the lines with arrow shapes. 2. Color alternate shapes with black. Variation: Fill an entire section with 'Necktie' tangles.

Woods

1. Draw a large zig-zag in a section. 2. Repeat the zig-zag with a second line. 3. Fill the spaces between the zig-zags with arrow shapes. 4. Color the zig-zag with black.

Itsy Bitsy

1. Draw moon shapes around the inside of a section. 2. Repeat the moon shapes to make a second row . Note: Look closely to see how to align of the points in the center of each moon arch. 3. Repeat the moon shapes to make a third row. Note: Each row will have smaller moon shapes. 4. Continue adding rows of moon shapes until you reach the center. 5. Color the center with black.

Beginning of a Mandala

Begin with a basic Zentangle process... the start of an expression, an experience, a journey, a story to be shared.

Straight orderly lines are often rational numbers and thoughts. Curves are often emotional and irrational.

Black and White

In Eastern philosophy, black represents the unknown. It is a power color, the unification of all colors. In the West, white suggests purity, spirituality and light, the absence of color,

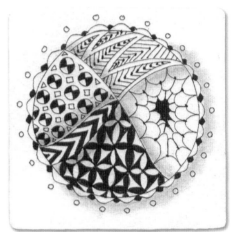

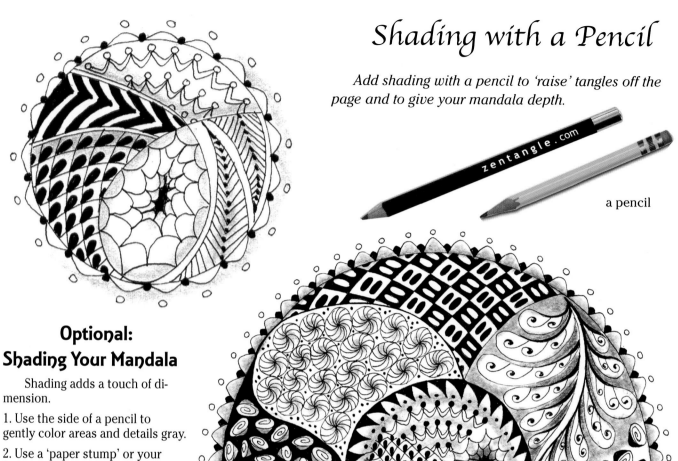

Shading with a Pencil

Add shading with a pencil to 'raise' tangles off the page and to give your mandala depth.

a pencil

Optional:
Shading Your Mandala

Shading adds a touch of dimension.

1. Use the side of a pencil to gently color areas and details gray.

2. Use a 'paper stump' or your finger to rub the pencil areas to smudge, soften and blend the gray shadows.

Note: Use shading sparingly. Be sure to leave white sections white.

Where to Add Shading...

• Around the outside edge of a section

• In background spaces

• On one side of a tangle

• Along the edges of a section

• Along the right edge and the bottom of your finished shape

• Make shading about 1/8" wide, to 'raise' tangles off the page.

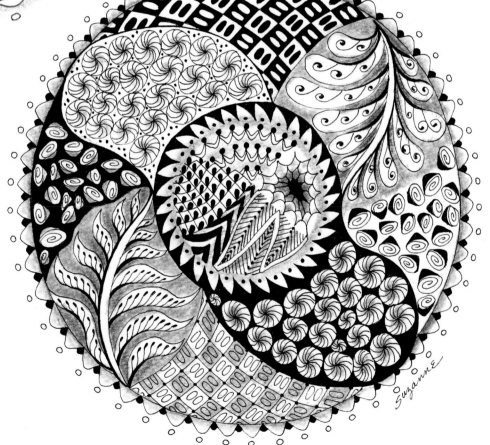

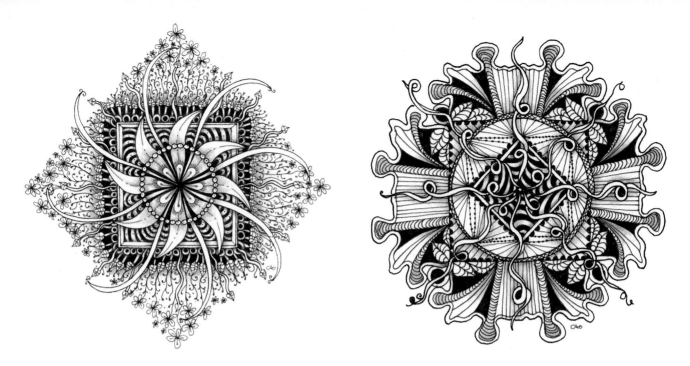

Snowflake Mandalas

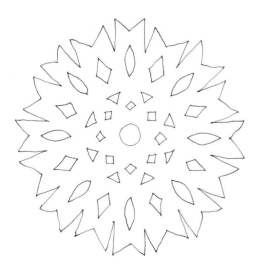

Fold and cut a snowflake

When it comes to math, I have to admit, my eyes glaze over and my brain goes into a sort of panic. Even though I loved and admired mandalas, I was hesitant about my abilities to get started with the measuring, planning, and the fractions! I did a few this way, but the tension and planning was just not for me.

Method 2 – Cut a Snowflake

Then I discovered a way of doing it that bypasses all of that. With the encouragement of some new Facebook buddies (Jane Snedden Peever and Verlie Murphy), I did my first "snowflake" mandala: Fold a piece of ordinary paper into triangles (like a paper airplane). Make a few cuts into the edges, unfold, then trace the cut areas in light pencil onto your art paper. These pencil lines become your guides.

Draw Tangles

Using an 01 Micron pen from this point on, make a mark that connects one point of a pencil shape to another. You can start in the center, or anywhere on the mandala. Whatever mark you make, make that same mark all around the mandala. Then make another mark, and make that same one all the way around the mandala.

Focusing on each mark without worrying about what the entire mandala will look like is the important element. As you focus on each mark, relax and let the next step come to you. Don't try to control the look of your mandala, but allow each mark to magically become a whole new shape as it connects to the marks before it.

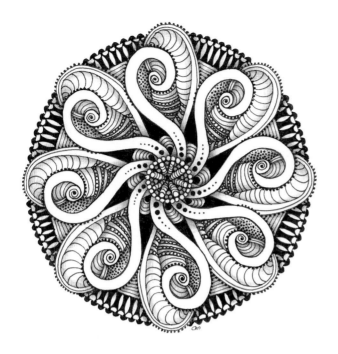

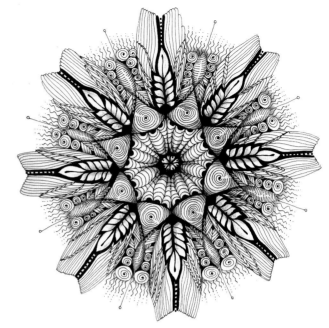

Snowflake Mandalas by Carol Ohl, ©2010

After a while, you will see shapes and patterns simply emerge without your planning. This is the most fun! Once you feel all your marks are made, sit with the design and let it tell you what to fill with tangles, or what to shade (or even IF you want to shade). What pops out? What recedes? The answers you have won't be the same as anyone else's, and they will be neither wrong nor right.

You can use the same snowflake template over and over, and I guarantee you won't ever get the same mandala!

Carole Ohl, CZT

Carole is a CZT who lives in Dayton, Ohio. Along with her passion for Zentangle, she also loves beading and her 'real' job of graphic design.

She is always up for a new art adventure, and she has the most fun when she is teaching and sharing with others who want to learn.

You can email her at caroleohl@woh.rr.com.

Visit Carole's blog at openseedarts.blogspot.com.

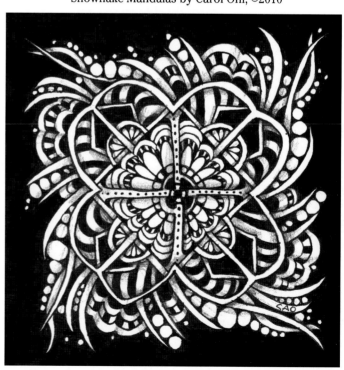

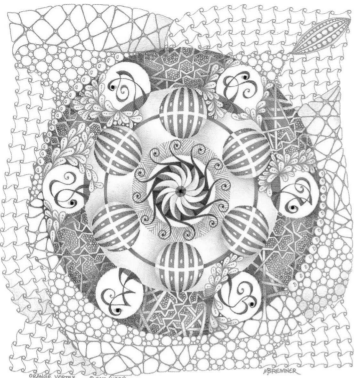

ORANGE VORTEX © 2010 (167 BE) M.BREMNER

©2010 by Margaret Bremner,

Details and Tangles

Ever since I was a little girl I have thought of myself as an artist. I was never really interested in being anything else. I gaze at things, trying to figure out how they work visually. I love details, so when I found Zentangle, I knew that is was perfect for me.

Once, when I was chatting with a friend, he stopped mid-sentence and asked, "What are you staring at? What is it?" I was staring intently, fascinated by how the checked pattern on his shirt changed direction when it passed through a fold.

A Rainbow of Colors

Colors, patterns, visual textures and designs thrill me. I love how a line can change from chubby to hairline and back again. Prairie sunsets, fireworks, and night skies full of stars leave me speechless.

I like small things and details. I am fascinated by how the very large and the very small are very similar. I love translucence, colored glass, light on water and sparkly things. Art and beauty fill me with spirit.

Colorful Mandalas

Mandala artwork has been my focus for over 15 years. (I've always preferred geometry to algebra!) I am attracted to mandalas because the roundness of a circle is an ancient and cross-cultural symbol of wholeness, eternity, protection, and unity, while the mandala has the added symbolism of balance, transformation and interconnection.

Mandalas welcome color and detail, two things I love. I encountered zentangle on the internet in early 2008 when I was living in China. It really clicked with my love of detail, pattern and the graphic quality of drawing.

I greatly enjoy sharing with others.

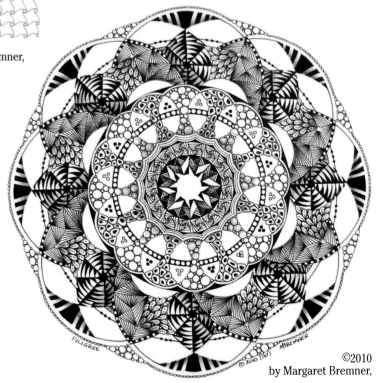

FILIGREE © 2010 (16?) M.BREMNER

©2010
by Margaret Bremner,

Mandalas – Orange Vortex

page 12
Size: 9" square
Margaret used *Sakura* Micron 01 colored pens to draw the design and tangles. She added stronger colors with colored pencils and accents with tiny gems.

Filigree

page 12
Size: 9" circle
Margaret used *Sakura* Micron 01 black pens to draw the design and tangles. She added shadows with a grey colored pencil and accents with tiny gems.

Blue Whirl

Size: 8" circle
Margaret used *Sakura* Micron 01 colored pens to draw the design and tangles. She added stronger colors with colored pencils and accents with tiny gems.

Photos: Grant Kernan, AKPhotos

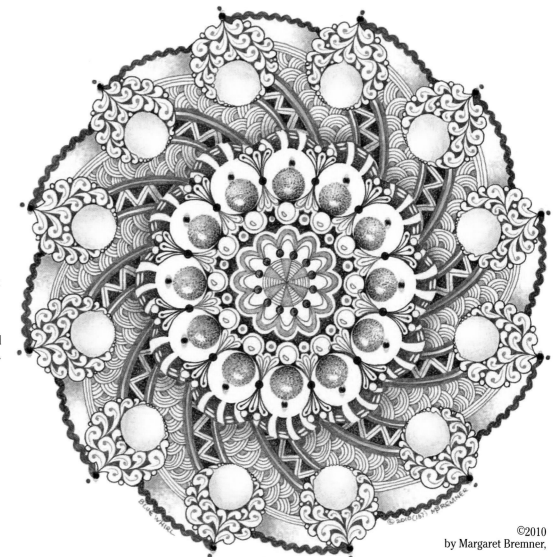

©2010
by Margaret Bremner,

Margaret Bremner, CZT

Margaret holds a Bachelor of Fine Arts degree. She has completed numerous commissions for businesses and individuals, and her illustrations have appeared in many magazines.

With intricate detail, fine craftsmanship, and touches of whimsy, Margaret works in pen and ink, acrylics, colored pencil, collage, and mixed media. She frequently incorporates "fun stuff" such as tiny gems, brads, or metal disks. Margaret's hope is to create artwork that uplifts the spirits, is a source of comfort and tranquility, and reinvigorates a sense of the sacred in our lives.

Email: margaret.bremner.artist@gmail.com
Blog: www.enthusiasticartist.blogspot.com *Website:* www.artistsincanada.com/bremner

Mandalas with a Stencil

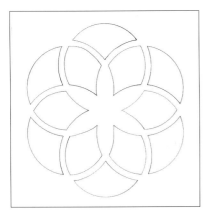

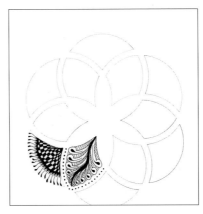

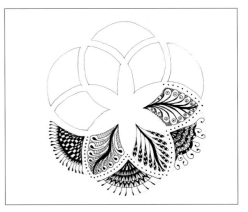

String for Mandala

1. Use a plastic stencil with a circular mandala image and a pencil. Trace through each section with the pencil for the basic mandala. Remove the stencil.

Tangles

2. Use a Micron 01 black pen to draw a tangle in each section.

Tangles

3. Draw a different tangle in each section or repeat the same tangle in the sections that are the same shape.

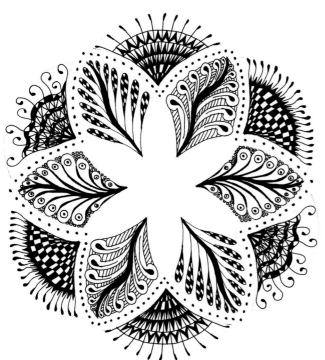

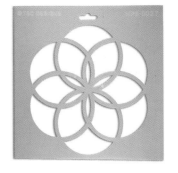

Use a plastic stencil with a circular mandala template (#MPS-0027 from teacherstamp.com).

Method 3
Mandalas with a Stencil

Additional Supplies You'll Need

Use a plastic stencil with a circular mandala shape as a guide for making the divisions. This simple tool is inexpensive and easy to use. Simply draw through each section with a pencil as a guide. Fill the sections as desired. You can also alter the shape of sections as desired. Every mandala will be different, even when you use the same stencil.

Geometric Mandalas

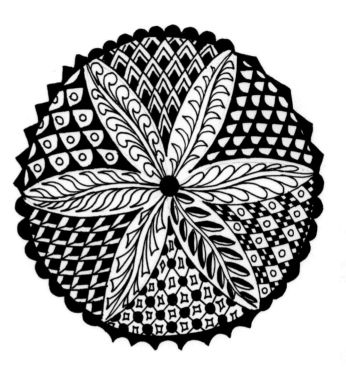

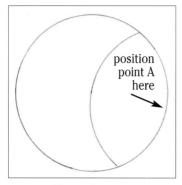

Frame

1. Use a pencil and a compass (or a round shape) to draw a circle.

Use a Compass

position point A here

2. Use the same compass setting, position the point at A and draw a curved shape on one side.

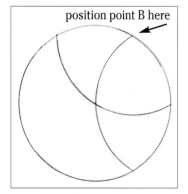

Compass

position point B here

3. Position the second point B on a curved line, draw another shape.

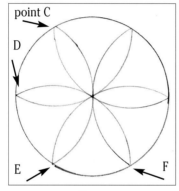

Compass

point C

D

E F

4. Continue drawing curved shapes (as in step 3) around the circle.

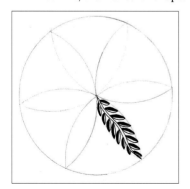

Tangles

5. Use a Micron 01 black pen to draw a tangle in each section.

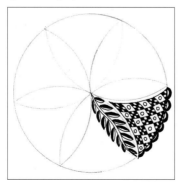

Tangles

6. Draw a different tangle in each section or repeat tangles.

Method 4

Mandalas with a Compass

Additional Supplies You'll Need

A compass for drawing the circle and curves.

A protractor is handy for measuring regularly divided sections for irregular divisions (see individual instructions for the °).

Symbolism

 Water Droplets

Just as tears replenish your eyes, raindrops quench the dusty ground, making it possible for new growth to flourish. In the same manner, water rituals heal and cleanse the soul.

 Eyes

These 'windows of the soul' convey emotion more powerfully than words. The ability to see extends past physical reality into the unconscious. Eyes in a mandala represent heightened perception.

 Flowers & Leaves

Representing eternal rebirth, flowers form naturally in the shape of mandalas. Use them to signify personal growth and life energy.

 Hands

Those who actively participate in life are called hands-on. The hand can express anger and compassion. It has the ability to hurt or to heal. The right hand is considered rational while the left hand is emo-

 Spiral

This symbol of revitalizing life force expresses your growing knowledge. Let your creative spirit absorb new inspiration and express these insights with spiral shapes.

 Heart

The heart is universally the symbol of love. It represents joy, happiness, rapture, contentment. Sometimes the heart often must remind the head to focus on that which is most important.

 Lightning

Whether the bolt comes from Zeus or an exchange of energy between earth and sky, lightning is impressive in its power to dazzle and awe. Lightning is dynamic so use it to express sudden illumination, sparks of insight, or dramatic change in your life.

 Rainbow

The phrase 'chasing rainbows' refers to impossible pursuits, and yet rainbows lure us with the promise of possibilities. Rainbows celebrate possibilities, so celebrate their appearance in your mandala and open your mind to the promise of beautiful things to come.

 Square

The symbol of rational thought, this shape with equal sides and equal angles represents stability and can be considered the cornerstone of achievement.

Web

Spiders create a home by weaving and generating an amazing and fragile web. The beautiful web and the spider are associated with creation, life and creativity.

 Tree

Trees represent growth and lifeforce. They protect animals from the elements and provide a sanctuary for birds. Trees cleanse our atmosphere and preserve our planet from drought.

If you feel disconnected, put down roots by adding a tree to your mandala.

 Star

When Leonardo daVinci drew his famous diagram of man, he discovered a 5 pointed star. Those with the tenacity to realize their dreams are often described as 'reaching for the stars'. Stars reflect determination, sense of purpose and self worth.

 Triangle

The double triangle forming a 6-pointed star represents fulfillment and harmony. The upward triangle represents the fire of creative life force while the downward triangle symbolizes water and potential.

Because triangles rotate on a center point, they indicate change.

 Circle of Protection

From the circle of a mother's protective embrace to round war shields, man has long associated safety with circles. Circular amulets guard man from disease and attack. Learning from herds of animals, nomadic groups arranged their camps in circles, placing the most vulnerable and valuable in the center.

The circle of a mandala is often considered to be a circle of protection, whether you are facing an external threat from natural disaster or an emotional threat such as fear of failure.

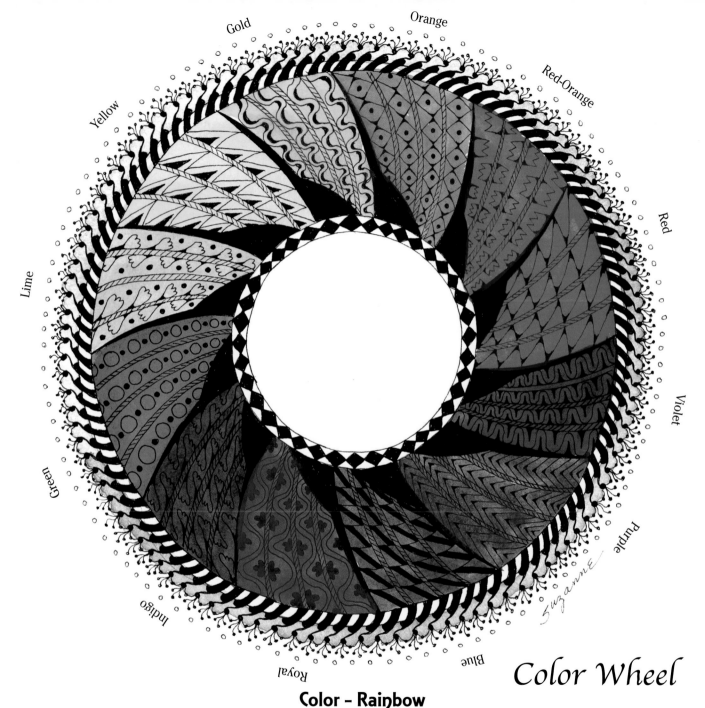

Gold

Orange

Yellow

Red-Orange

Lime

Red

Green

Violet

Indigo

Purple

Royal

Blue

Color Wheel

Suzanne

Color – Rainbow

The interaction of color adds another layer of meaning to a mandala. Just as relationships can be congenial or co-operative or hostile, knowing the color combinations that convey these messages can help with clear expression.

The rainbow is a natural display of colors. Viewed as a blessing, a rainbow excites feelings of anticipation and joy.

Adding Color to Mandalas

Color has the power to affect human emotions. The emotional interpretation of color varies from one culture to another, so every interpretation is 'correct'. In this book you'll find a collection of generally accepted meanings of color intended to inspire exploration of a rainbow of possibilities. In a mandala, color communicates feeling. The color placed in the center represents what is most important to you at the time.

Using a single color indicates intense focus; a variety of colors shows a distribution of energy over several interests.

The Color Golden

Associated with prosperity, golden is the color of ripe grain, the source of our daily bread. It can also be seen in the fires that light our way, cook our food, and bring us together for stories beneath the stars.

The Number One

The individual, solitary ego, set apart from all else is often represented by a seed, such as an acorn. Paradoxically, one also refers to 'oneness', a unity with the divine that simultaneously encompasses both the individual and the whole.

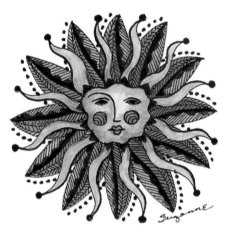

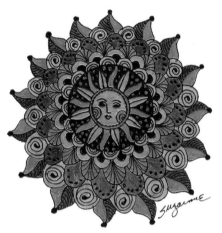

Watercolors

Draw the design and tangles with *Sakura* Micron black pens (they dry almost immediately). Next use water and watercolor paints to brush colors over each section. TIP: The KOI watercolor travel set by *Sakura* is very handy.

Watercolor Pencils

Draw the design and tangles with *Sakura* Micron black pens. Color each sections with watercolor pencils.
TIP: Add darker colors on top to create shading. Brush water over each section (one section at a time) to create a wash.

Color Pens

Draw the design and tangles with *Sakura* Micron black pens. Use colored *Sakura* Micron pens to fill each section with colors. Add colors as desired,
TIP: Alternate 'warm' - red and orange and 'cool' - blue and green colors.

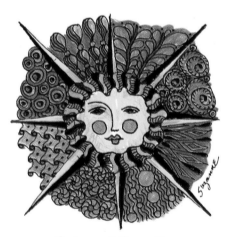

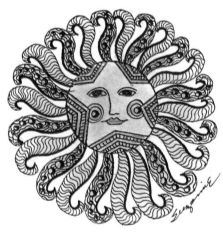

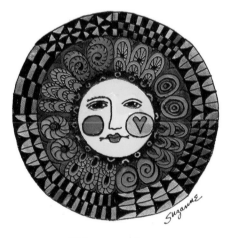

Colored Pencils

Draw the design and tangles with *Sakura* Micron black pens. Color each section with a colored pencil. TIP: Add darker colors in detail areas and backgrounds to create shading and color interest. TIP: Contrast a 'light' - yellow face with 'dark' - red/pink background.

Chalk

Draw the design and tangles with *Sakura* Micron black pens. Use a stipple brush or applicator to apply colors of chalk over each section as desired.
TIP: *Craf-T* makes a handy palette of assorted chalk colors. TIP: Color chalks will give a look that is soft and delicate.

Watercolors

Use a black pen to draw then add watercolor paints. For darker colors, add a second or even a third layer of colors. Also you can alter the colors by painting one thin color over another - such as blue over yellow creates green, or red over yellow makes orange.

Variations of Circles

Jelly Fish

 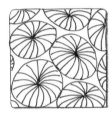

Tangles

Let the mandala guide in your choices of tangles. Express joy, gratitude, anger, frustration, resentment, and passion without judgment. When you accept all feelings, you regain a sense of well-being and proportion.

As you choose your tangles, silence the inner critic and immerse yourself in discovery, proceeding without fear. The real you, the undiscovered you is greater and better than you ever realized.

Holes

Juggle

Variation

Circles

Variation *Variation*

Jelly Donuts

Effervescence

Anchor Chain

Orange Peel

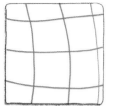 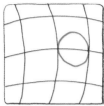 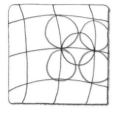

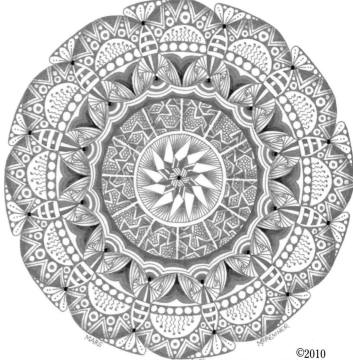

©2010
by Margaret Bremner,

Mars Mandala Size: 8"

Margaret used *Sakura* Micron 01 colored pens to draw the design and tangles. She added stronger colors with colored pencils and accents with tiny gems.

Photo credit: Grant Kernan, AKPhotos

Variations of Grids

Tufted Leaves

 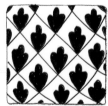

Board Game

 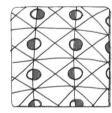 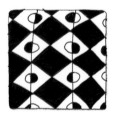

Footprints

Tangles

Use your feelings as a guide. If you are feeling rigid or angry, use straight lines and jagged points. As that energy transforms, introduce curves to balance your mandala with some softness.

Chaotic patterns indicate confusion and indecision. Do not dismiss these thoughts as bad. Simply allow them a space, and observe the ways in which nonjudgmental thoughts change the way you think about yourself.

Variation *Variation*

Floor Tiles

 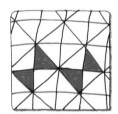 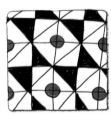 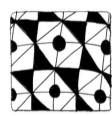

Wavy Lines

Cheesecloth

Wavelength

Cells

Chinese Lanterns

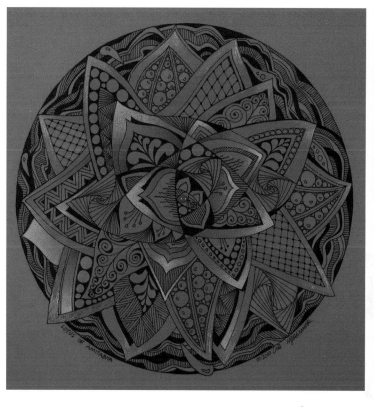

©2010
by Margaret Bremner,

Red Mandala – Lotus of Amitabha

Size: 6" square

Add stunning red color by simply drawing on artist paper.

Margaret drew this Mandala on red MiTientes colored paper. She used *Sakura* black Micron pens to draw the design and tangles. She added highlights with a white colored pencil and painted red acrylic paint in the bright areas.

Photo credit: Grant Kernan, AKPhotos

Variations of Parallel Lines

Papyrus

Water Slide

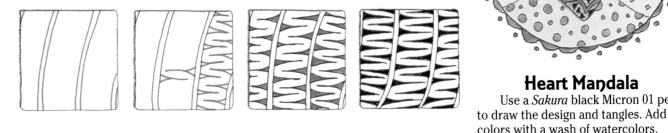

Heart Mandala

Use a *Sakura* black Micron 01 pen to draw the design and tangles. Add colors with a wash of watercolors.

Braid

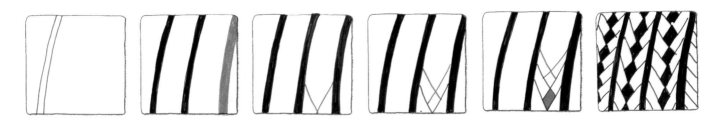

Combs

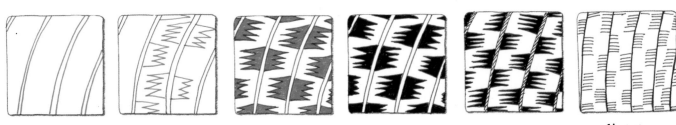

Variation

Variations of Parallel Lines

Spacer Beads

Variation *Variation*

Partly Cloudy

Variation *Variation*

Cable TV

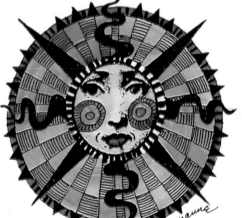

Wrought Iron

 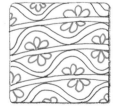 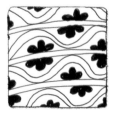

Face Mandala
Use a *Sakura* black Micron 01 pen to draw the design and tangles. Add colors with a wash of watercolors.

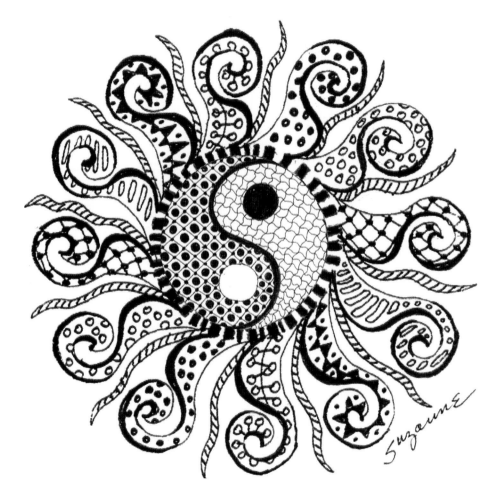

Emphasize the Center

The center represents the beginning, the divine source, the fountain of goodness, the well-spring of all energy.

Astronomer, astrophysicist and cosmologist Carl Sagan reminds us, "When too much cynicism threatens to engulf us, it is buoying to remember how pervasive goodness is."

Emphasize the good at the core of your being by drawing attention to the center of your mandala. Doing so adds dimension and texture to your art and focuses attention on what is important.

In this mandala, I drew a Yin-Yang and then surrounded it with Octopus and Stem shapes then I filled each shape with tangles.

Burdock

Pitcher Plant

Fandango

 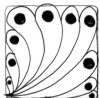

Variations of Leaves and Shapes

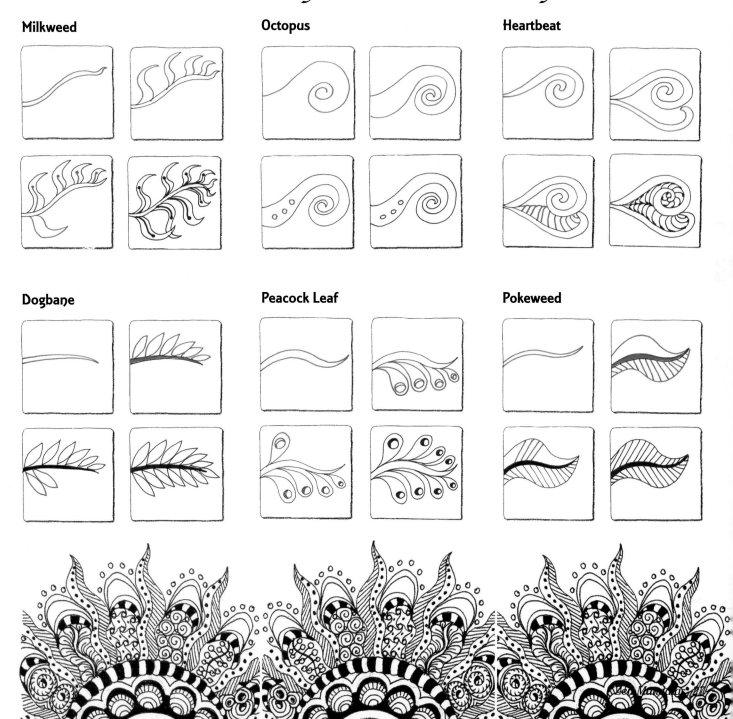

Milkweed

Octopus

Heartbeat

Dogbane

Peacock Leaf

Pokeweed

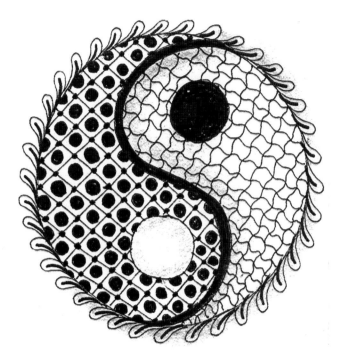

The Meaning of Yin-Yang

The paradoxical union of spirit and matter have always puzzled man. The Yin-Yang symbol describes the interconnection and interdependence of seemingly contrary forces - the male and female, light and dark, hot and cold, good and evil.

The Yin is characterized as slow, yielding, tranquil, feminine, water, moon, and night while the Yang is masculine, aggressive, heated, focused, fast, fiery, intense, sun, sky and daytime.

Lollipops

Aloe Vera

Pineapples

Eyebrows

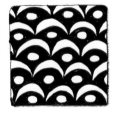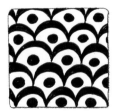

Variation

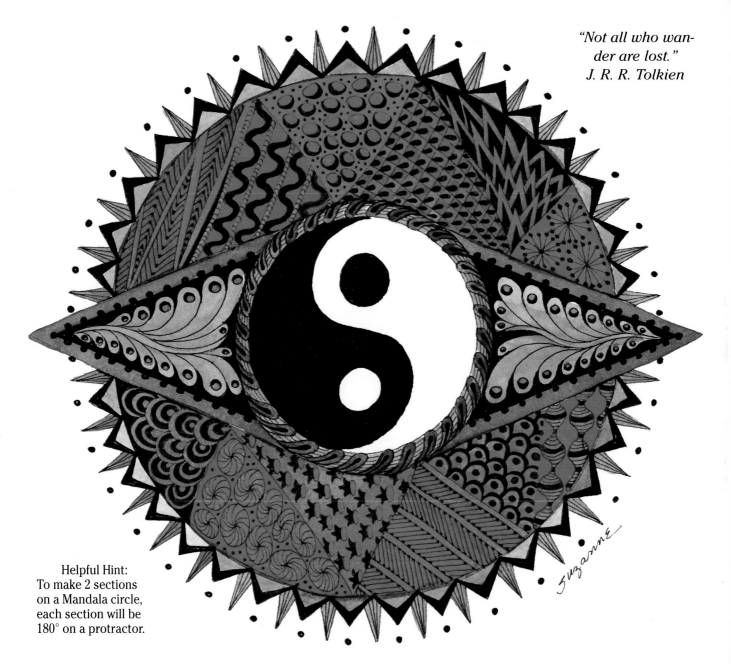

"Not all who wander are lost."
J. R. R. Tolkien

Helpful Hint:
To make 2 sections
on a Mandala circle,
each section will be
180° on a protractor.

The Colors Red and Pink and Orange

Celebrate your personal growth at the end of each day with the colors of the sunset. The mixing of red, pink and orange celebrate your harvest of well-earned rewards, the completion of tasks well done and obligations met.

The Number Two

Two allows creation, engenders symmetry, instigates opposites. The concept of two is expressed in sunshine and shadow, yin and yang, male and female. It is the marriage of opposites that restores the harmony of the one.

Zen Mandalas 29

Planet Earth

"There is a sufficiency in the world for man's need but not for man's greed." ~Mohandas K. Gandhi

Earth and Nature are maintained in a complex, nurturing, balanced ecosystem of which we are all equally vital components. No other planet in our solar system has the ability to support life, making Planet Earth unique. Take time to appreciate the beautiful diversity and teeming life force that makes our planet the greatest home in our universe.

Turtle

Lizard

Snake

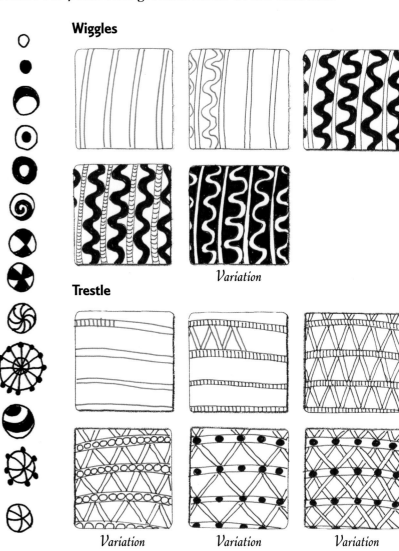

Wiggles

Variation

Trestle

Variation *Variation* *Variation*

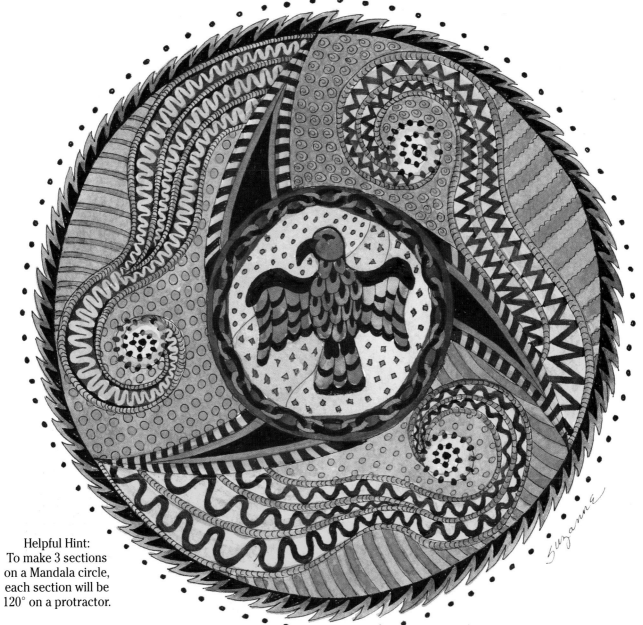

Helpful Hint:
To make 3 sections
on a Mandala circle,
each section will be
120° on a protractor.

The Color Green

Nature bursts forth every spring bedecked in every shade of green imaginable. All is reborn, new, fresh, and full of promise. Green is the color of harmony, a fact expressed in the Native American proverb, "No tree has branches so foolish as to fight amongst themselves."

The Number Three

Excitement, vitality, and motion are embodied in the concept of three. Because it represents the beginning, middle, and end, three encompasses completeness. It denotes insight and the rise of consciousness to a higher level and possesses a feminine nature.

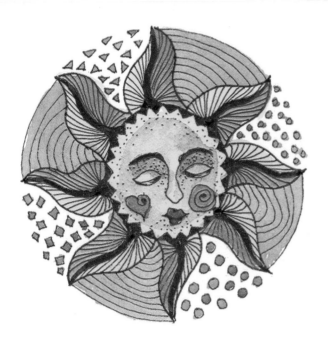

Sun and Compass

Sun Mandalas

Since the first day, light has been associated with good. The miracle of each dawn gives us cause to rejoice and give thanks.

Sunshine makes us happy... it heals the melancholy mind; it lifts our spirits; it brightens our day. Is it any wonder that early cultures worshiped the sun god?

In Egypt, his name was Ra. The Greeks called him Helios. In both cultures, the sun god drove a chariot across the sky during the day.

Your Moral Compass

Let your consciousness awaken through meditation and give it form in a mandala. Your inner self knows what is right and good. Listen to that voice.

"Nothing is as sacred as the integrity of your own mind." Ralph Waldo Emerson

Colosseum

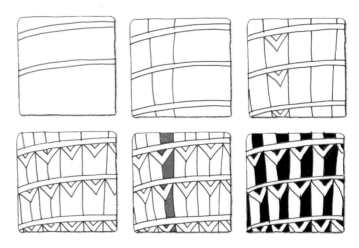

Spear Point

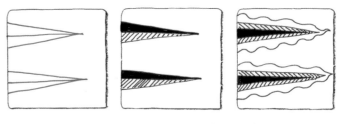

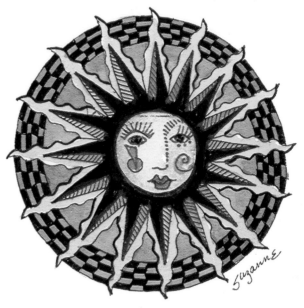

North

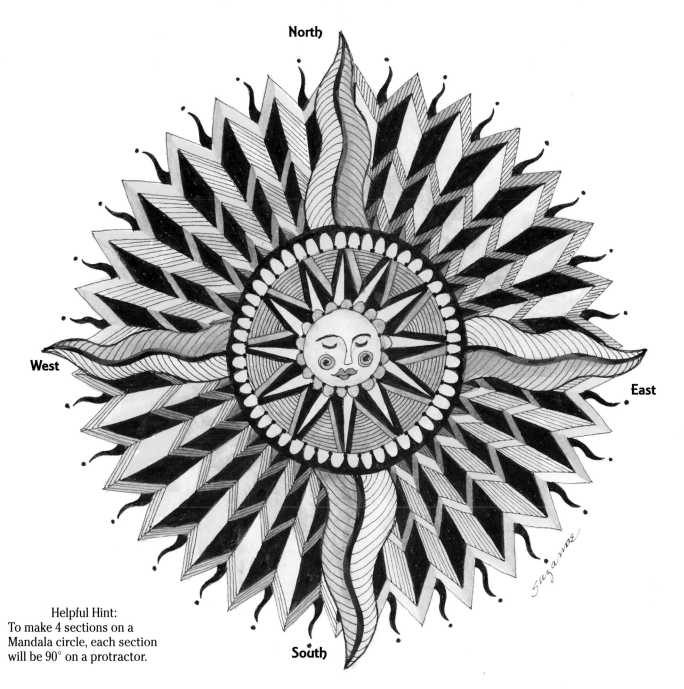

West

East

South

Helpful Hint:
To make 4 sections on a
Mandala circle, each section
will be 90° on a protractor.

The Color Yellow
Bright, happy yellow is the color of the sun; our
planet's source of light, warmth and life. Yellow
represents our ability to see and thus to understand.

The Number Four
The harmony and order of the universe are expressed in
terms of four - four seasons, four compass directions. The solid
logic of the square gives the number four a masculine nature.

Heavenly Bodies

Stars

What man, woman or child has not gazed at the night sky and wondered at its beauty and felt humbled by its majesty? Astronomer Carl Sagan liked to say, "You are the stuff that stars are made of."

More than elements such as iron and magnesium, we share a common energy. We all experience gravity and light. We are all passengers revolving about the sun in a solar system precariously positioned on an outer arm of a spinning galaxy known as the Milky Way.

Moon

Man-made lunar calendars have been found dating back to 25,000 BC, proving that our ice-age ancestors were as fascinated by Earth's only satellite as we are.

Like the sun, the moon was often worshiped as a deity. Because the phases of the moon correspond with a monthly rather than a yearly cycle, the moon was often associated with a fertility goddess. Many believe the force exerted by the moon - which is powerful enough to create tides - also affects the human psyche.

Star Shapes in Nature

Starfish

Sand Dollar

Flower

Fruit

Caps

Dandelion Seeds

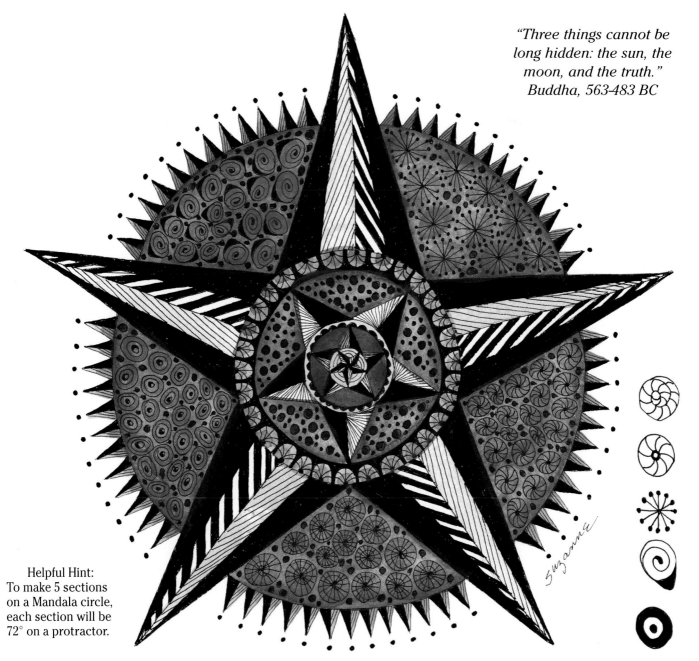

"Three things cannot be long hidden: the sun, the moon, and the truth."
Buddha, 563-483 BC

Helpful Hint:
To make 5 sections
on a Mandala circle,
each section will be
72° on a protractor.

The Color Blue
Clear skies, calm waters, and cool shadows; soothing blue suggests serenity. Some believe blue is the color of the soul. Indigo appears in the rainbow. Indigo in a mandala is deeply philosophical, associated with the attainment of wisdom and an awakening of intuition.

The Number Five
Quinta essentia, the number 5 represents an active pursuit of life to the fullest. You are well grounded, with a firm stance, like daVinci's man vector drawing. Five symbolizes health, love and wholeness of being.

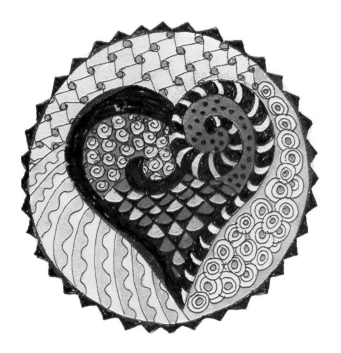

"The day that thou dost pass devoid of love.
For thee is none more wasted than that day."
Omar Khayyam

Love is the broadest and most comprehensively intense of all human emotions and more has been written upon this subject than any other in human history.

Whether your mandala describes the vulnerability of a fresh love, a brightly burning passion, the surety of a life-long friendship, an unrequited love, a lost love, or simply a sense of compassion for all living things, let your heart speak freely. Trust that your expression will be genuine and remember that faith may move mountains, but love conquers all.

Love and the Heart

Heart

Did you know that the universe and every component therein, down to the smallest particle, resonates with a pulsating beat? This is the energy of life. Listen to waves crashing on a beach and you will hear the heartbeat of our planet.

When you meditate, your heart rate slows, preserving that life-giving pump by giving it a much needed rest. Meditation offers an opportunity to open your heart. It teaches us to be more aware of the tribulations of those around us. In the presence of this awareness, our compassion grows.

The Dalai Lama proposes, "If you want others to be happy, be compassionate. If you want to be happy, be compassionate." There is nothing more worthy than a compassionate heart.

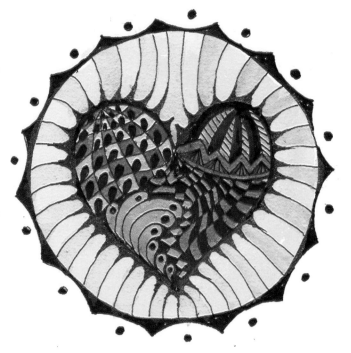

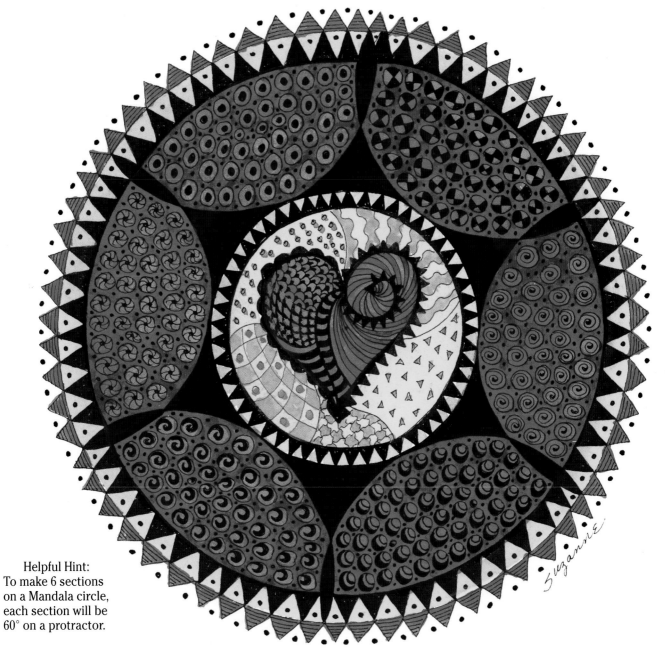

Helpful Hint:
To make 6 sections
on a Mandala circle,
each section will be
60° on a protractor.

The Color Red

Perhaps because human blood runs red, red is the color of life. Passionate, energized, potent and powerful, red is the fire that burns away ignorance and marks new beginnings. It is the color of healing and the transformation to greater wisdom.

The Number Six

From Biblical references to ancient Greek texts, the number six has been the symbol of creation completed. Signifying accomplishment, celebrate the fulfillment of a wish and the satisfaction of a job well done.

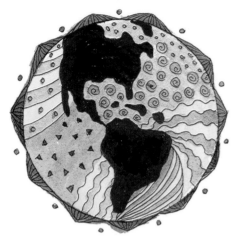
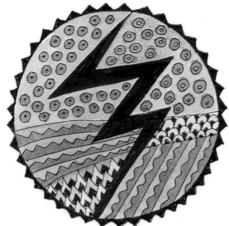
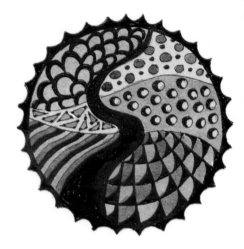

Water and Earth

Twenty-five centuries ago, Lao-tzu, a Chinese prophet, wrote the Tao Te Ching. In it, he spoke often of water. "The supreme good is like water which nourishes all things."

Water is the life source of our planet. It is the force that carves the hardest granite and the yielding mist that replenishes each leaf, flower and blade of grass. Lao-tzu observed, "Nothing in the world is softer and weaker than water, but for attacking the hard, the unyielding, nothing can surpass it."

If you wish to find true inner peace, imitate water. While wind ripples the surface of a pond, it does not disturb the stillness below. Be like the water. Let the bluster of others pass over your surface like ripples in the pond while in your depths you remain calm.

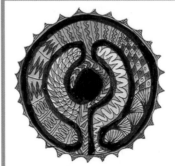

Labyrinth

In Greek mythology, the labyrinth was built by Daedalus for King Minos of Crete at Knossos for the purpose of holding the minotaur. Thus, labyrinths have a reputation for serving as traps for malevolent spirits.

In medieval times, the labyrinth symbolized the path to God, having a clearly defined destination, one entrance, and many opportunities to go wrong along the way. Today, labyrinths are used by mystics to help achieve a contemplative state. Walking among the turnings, one loses track of direction and of the outside world.

To the western mind this disconnection may be frightening. The voice within whispers, "What if I can't find my way back?" This is just one example of the way our brains have been conditioned to prevent us from connecting with the silence of our inner selves.

Be confident and still your fears with the reassurances of Psalm 51:8: "In my innermost being you teach me wisdom. Not only will you find your way through the labyrinth, you will meet your better self along the path."

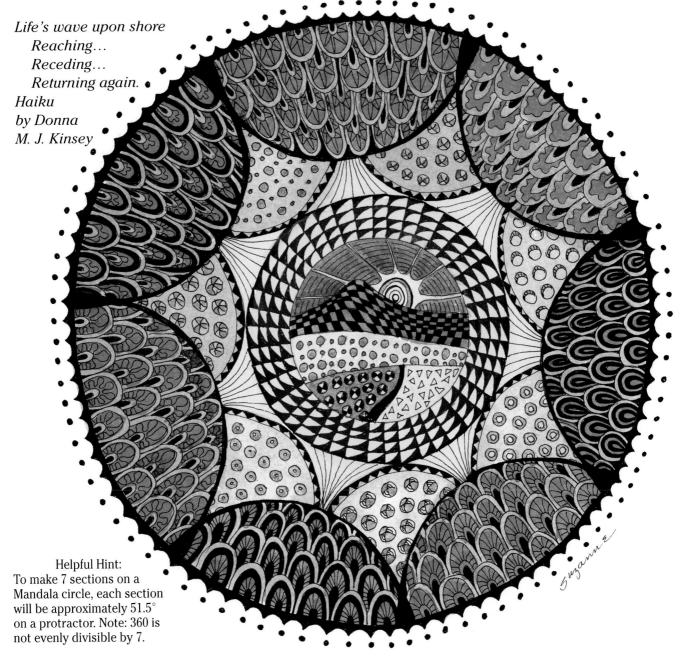

Life's wave upon shore
 Reaching…
 Receding…
 Returning again.
Haiku
by Donna
M. J. Kinsey

Helpful Hint:
To make 7 sections on a
Mandala circle, each section
will be approximately 51.5°
on a protractor. Note: 360 is
not evenly divisible by 7.

The Color Lime

Lime is a mix of yellow and green. Every spring, tender lime-colored shoots, so full of potential and promise burst to life. Use lime in your mandala to express new growth, new thoughts, and hope-filled plans.

The Number Seven

Indivisible and prime, seven has long been revered. Perhaps because there are 7 colors in the rainbow, 7 is considered lucky. Symbolizing ambition, 7 was the final phase in the alchemist's quest to transform lead into gold.

Hands All Around

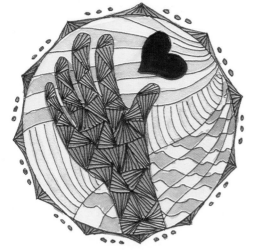

Open Hand of Peace

*"Too often we underestimate the power of a touch,
a smile, a kind word, a listening ear, an honest
compliment, or the smallest act of caring, all of
which have the potential to turn a life around."*
Leo Buscaglia

*Hands are effective communicators. An open hand is
welcoming, a fist threatening. A tensed hand conveys our fear.
We raise our hands to heaven in joyous praise and when
making desperate pleas for aid. We often speak of leaving
matters of import 'in God's hands'.*

*Hands are a metaphor for yin-yang because they can both
hurt and heal, help or hinder, wield a weapon or offer peace.*

*In the words of Shakespeare, "Join your hands
and with your hands, your hearts". Be at peace.*

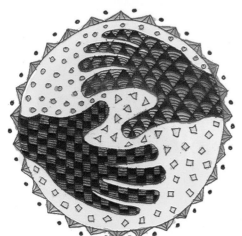

*"The glory of friendship is not the outstretched hand, nor
the kindly smile... it's the spiritual inspiration that comes to
one when he discovers that someone else believes in him
and is willing to trust him with his friendship."*
Ralph Waldo Emerson

Love Letters

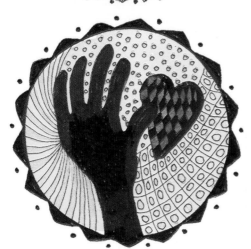

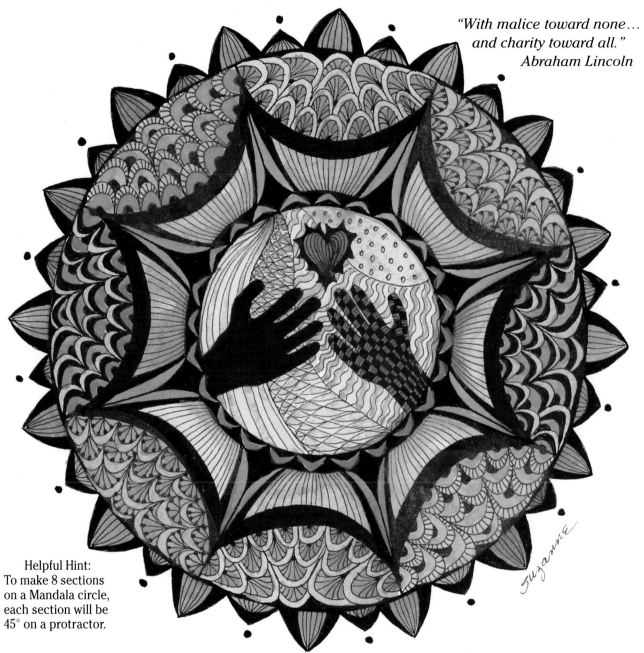

*"With malice toward none…
and charity toward all."*
Abraham Lincoln

Helpful Hint:
To make 8 sections
on a Mandala circle,
each section will be
45° on a protractor.

The Color Orange

Orange is the color of candle flame and sunset. Positioned between red and yellow in the rainbow, orange gives the impression of warmth. It vibrates with the energy of joy and determination, and often symbolizes ambition.

The Number Eight

Set on its side, 8 represents infinity and endless change. Upright, this combination of circles represents rebirth and stability. The pairing of circles that form an 8 represents the meeting of opposites in perfect harmony.

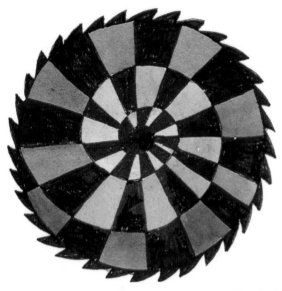

ing beyond the safety of what is accepted.

Henry David Thoreau, a leading 19th century transcendentalist, earned the disdain and even the wroth of his fellow citizens when he encouraged others to break free of the bonds of conformity.

Contemplate his words as you create your unique mandala. "If a man does not keep pace with his companions perhaps it is because he hears a different drummer. Let him step to the music he hears, however measured and far away."

Spiral

Every culture on the planet has drawn the form of a spiral. Inspired by the whorl of a shell or the buds of flowers, these natural designs invite us to experience life directly.

Spirals appeal to the independent mind. Unlike the circle, which flows infinitely upon itself, the spiral extends into the unknown, bravely reach-

Beaded Spiral

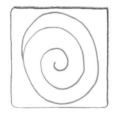 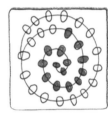

Marbles

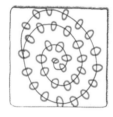

Striped Snail

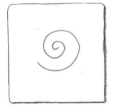 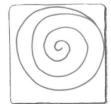 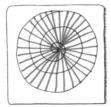

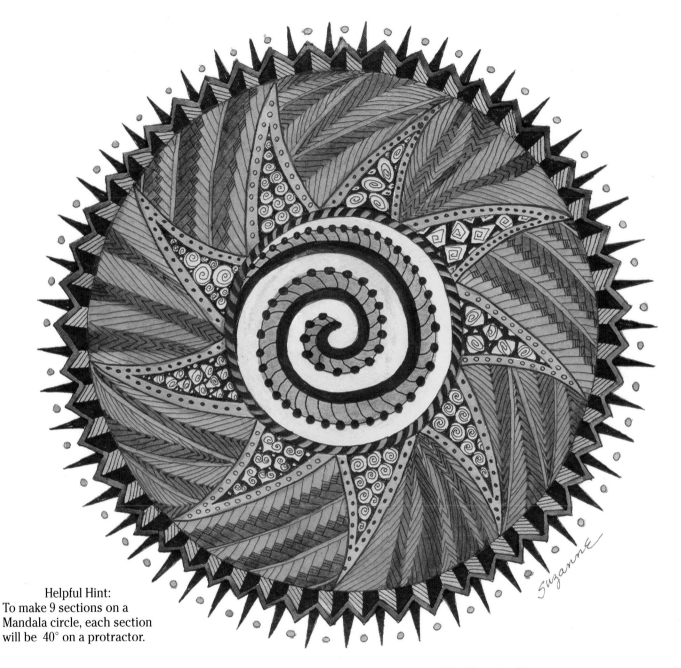

Helpful Hint:
To make 9 sections on a
Mandala circle, each section
will be 40° on a protractor.

The Color Turquoise
Combining serenity and rejuvenation, turquoise is a bluish-green gemstone believed to possess healing powers. When illness or loss interrupt your life, turquoise will find its way into your mandala.

The Number Nine
Being a perfect square and a triple three, nine has long been revered as a powerful sacred number. It represents the triple synthesis and balance of the physical, mental and spiritual and focuses the energy of truth which leads to personal growth.

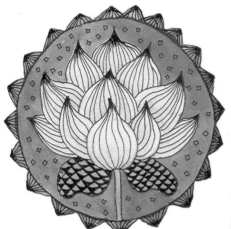

Lotus

Several traditions regard the Lotus as sacred, symbolizing the sun and the mysteries of enlightenment.

Because the stem connects the flower with roots deep below the water, the lotus is thought to expedite travel between the worlds, as one may do during meditation.

Because the flower closes and sinks beneath the water at night to emerge fresh in the morning, many associate it with rebirth and creation.

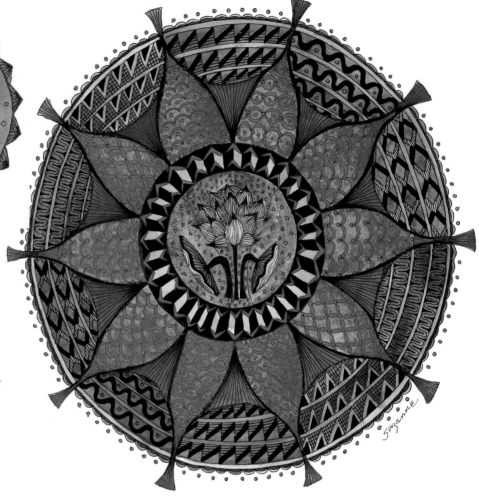

Helpful Hint:
To make 10 sections on a Mandala circle, each section will be 36° on a protractor.

The Color Violet

If purple increases understanding, violet ups the intensity to mystical experience. Often associated with virtue, violet is the color of Hermes, the winged messenger of the gods. Since the virtuous are most often favored by messages from the gods, it stands to reason that such exciting communication will be expressed in a color associated with vitality, focus, motivation, liveliness, and worth.

The Number Ten

Because one is male and zero is female, ten represents the symbolic marriage of opposites. Because we have ten fingers, this number can represent a hands-on approach to life. The ten Commandments give this number moral fiber.

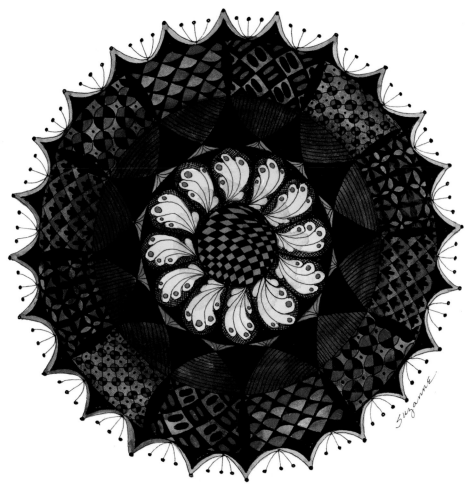

Symmetry

Symmetry is defined as the proper or due proportion of the parts of a body or whole to one another with regard to size and form; excellence of proportion. The ancient Greeks defined beauty based on or characterized by such excellence of proportion.

Rabindranath Tagore offers this thought on beauty to inspire the symmetry of your mandala:

"Beauty is truth's smile when she beholds her own face in a perfect mirror."

Helpful Hint
To make 12 sections on a Mandala circle, each section will be 30° on a protractor.

In "Ode on a Grecian Urn," John Keats wrote
"Beauty is truth; truth beauty. That is all ye know on earth, and all ye need to know." May, 1819.

The Color Purple
Once reserved for royalty, purple combines the power of red with the serenity of blue, Purple reminds us to develop a sensitive understanding. Use purple in your mandala to convey active imagination and creative endeavors.

The Number Twelve
In mythology, twelve often represents a passage of time to be endured. The Greeks honored 12 as a symbol of order in the cosmos with 12 gods on Olympus, 12 zodiac signs and 12 herculean tasks. The lotus flower has 12 petals.

Dream Catchers

Similar to a mandala, the dream catcher represents the web of life. Some Native American tribes believe the web catches the good forces of a dream or vision while, during the night, the bad dreams and forces pass through the center hole.

Other tribes believe that evil is trapped in the web to be dissipated by the light of day, while the good passes safely through the center.

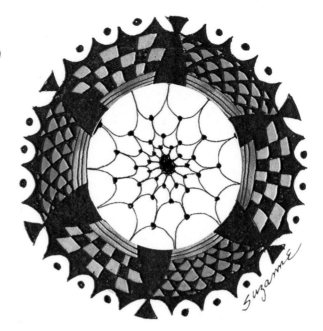

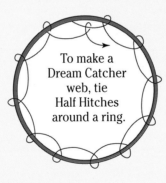

To make a Dream Catcher web, tie Half Hitches around a ring.

How to Wrap a Dream Catcher Web

1. Cut out a 3" - 4" circle in the center of a Mandala. 2. Punch a hole ¹⁄₄" from the center edge every 1" until you have six holes. 3. Cut a length of dark sinew or carpet thread 44" long. 4. Tie one end in a hole. 5. Make a Half Hitch in each hole. 6. On the second round, make a Half Hitch in each loop. 7. Continue until you reach the center (a small hole should remain) and tie a knot.

Cut off any excess thread.

Dream Catcher Legend

There is a legend of a Lakota spiritual leader who, while on a vision quest, met Iktomi, the trickster and teacher of wisdom. Iktomi appeared in the form of a spider. The spider picked up the elder's willow hoop which was decorated with feathers, beads and offerings.

On this hoop, the spider spun a web as he spoke to the elder. "Use this web to teach your people to make good use of their dreams and visions."

Today, many people hang a dream catcher above their bed to separate good dreams from bad ones.

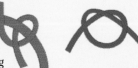

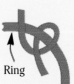

Ring

Half Hitch Overhand Knot Hanger

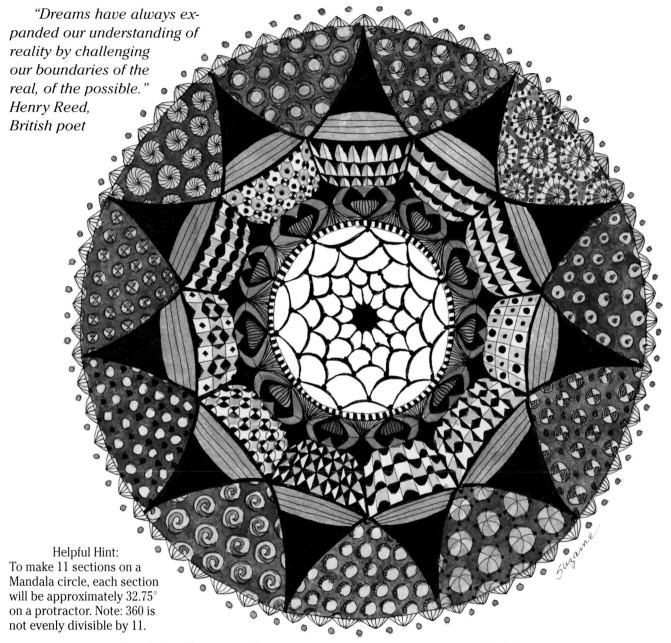

"Dreams have always expanded our understanding of reality by challenging our boundaries of the real, of the possible."
Henry Reed,
British poet

Helpful Hint:
To make 11 sections on a Mandala circle, each section will be approximately 32.75° on a protractor. Note: 360 is not evenly divisible by 11.

The Colors Brown and Rust

We don't call them 'earth tones' for nothing. Use tones and tints of brown in your mandala when you are feeling most connected to the earth. Rich soil and the manure that makes it fertile are brown, turning our attention once more to the unity of opposites.

The Number Eleven

Eleven represents the search for conflict resolution and stability. Eleven is the gatekeeper of regeneration.

Borders

Life is perpetually creative because it contains in itself that surplus which overflows the boundaries of time and space, restlessly pursuing its adventure of expression in forms of self-realization.

Borders and boundaries do more than enclose a space or contain an image. They entice us with the possibilities beyond the horizon ; that terra incognita - unknown earth.

When you anticipate the unknown with curiosity and wonder, draw your borders with thin lines that encourage the viewer to cross the line and contemplate what lies beyond the edge.

If your mandala represents protection, draw your border with a series of thick lines. Draw spiked edges to warn strangers to "Keep Out."

What is most important is to choose a border that fits the intention of your mandala.

Add Borders
To separate the center from the outer ring, I like to add a decorative border to outline the center.

To expand the circle of my Mandalas, I usually add an outer ring that adds detail to frame the circle.

Esker

Procession

Smoke Signals

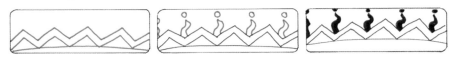

Pinking

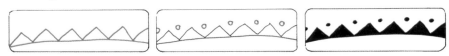

Hill & Dale

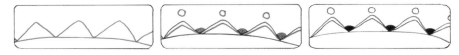

Alpine

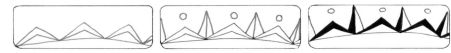

Mountains

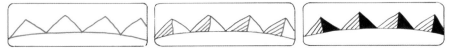

Rotate

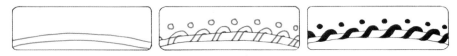

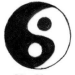

Yin Yang

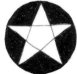

Star

Bull's Eye

Moon

Target

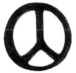

Peace

Fractured

Spiral

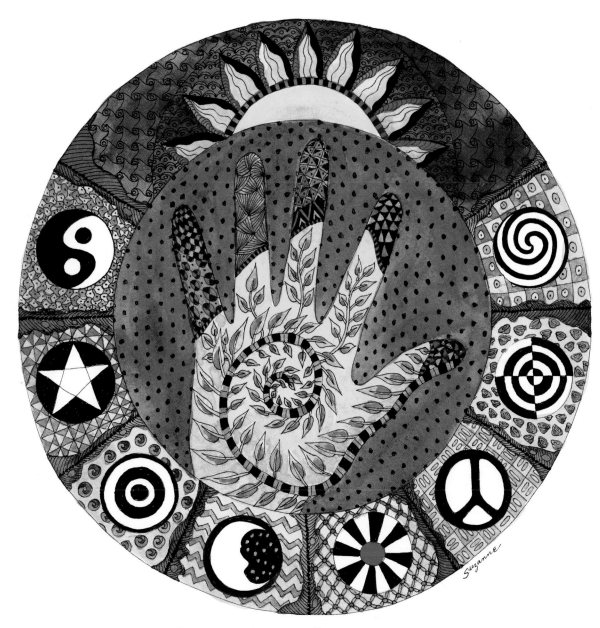

Good Luck - Hex Symbols

Use symbols to embellish a Mandala. For over 300 years, the Pennsylvania Dutch have decorated their homes, barns and documents with traditional symbols. Each design has meaning...blue - protection, white - purity, green - abundance and red - strong emotion.

60 Fun Tangle Patterns... from Zen Mandalas

Seedlings
page 7

Swag
page 8

Neckties
page 8

Woods
page 8

Itsy Bitsy
page 8

Jelly Fish
page 20

Holes
page 20

Juggle
page 20

Circles
page 20

Jelly Donuts
page 21

Effervescence
page 21

Anchor Chain
page 21

Orange Peel
page 21

Tufted Leaves
page 22

Board Game
page 22

Footprints
page 22

Floor Tiles
page 22

Cheesecloth
page 23

Wavelength
page 23

Braid
page 23

Cells
page 23

Papyrus
page 24

Water Slide
page 24

Braid
page 24

Combs
page 24

Spacer Beads
page 25

Partly Cloudy
page 25

Cable TV
page 25

Wrought Iron
page 25

Burdock
page 26

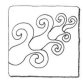
Pitcher Plant
page 26

Fandango
page 26

Milkweed
page 27

Octopus
page 27

Heartbeat
page 27

Dogbane
page 27

Peacock Leaf
page 27

Pokeweed
page 27

Lollipops
page 28

Aloe Vera
page 28

SUPPLIERS - Most stores carry an excellent assortment of supplies. If you need something special, ask your local store to contact the following companies.
SAKURA Micron Pens, Colors www.sakuraofamerica.com

ZENTANGLE - You'll find wonderful resources, a list of Certified Zentangle Teachers (CZTs) and workshops, a fabulous gallery of inspiring projects, kits, supplies and tiles. www.zentangle.com